PETER

C000200599

HISTORY TOUR

Originally published 2009
This edition published 2014

Amberley Publishing
The Hill, Stroud,
Gloucestershire, GL5 4EP
www.amberley-books.com

Copyright © June & Vernon Bull, 2014

The right of June & Vernon Bull to be
identified as the Author of this work
has been asserted in accordance with
the Copyrights, Designs and Patents Act
1988.

ISBN 978 1 4456 4148 5 (print)
ISBN 978 1 4456 4162 1 (ebook)

British Library Cataloguing in
Publication Data.
A catalogue record for this book is
available from the British Library.

Typesetting by Amberley Publishing.
Printed in Great Britain.

Map on pages 4 & 5 courtesy of
OS Streetview.

INTRODUCTION

Peterborough is more than a collection of buildings of offices, shops and civic centres. It is a place where people work, find leisure and live. It has a long and proud history from the Jurassic through Neolithic, Bronze, Roman, Anglo-Saxon, Medieval, Tudor, Georgian and Victorian to the present twenty-first century.

In more recent times, Peterborough has gone from a sleepy Fenland town to a vibrant city, and changes in the city's social history, political development, local government and religious influence have, more often than not, brought progress and an improved quality of life.

Peterborough owes its origins to the establishment of a Celtic monastery around 655, but only in Victorian times did the city begin to grow outside its medieval streets, mainly due to its new role as a major railway centre.

Today, the city continues to expand in the new millennium as a regional centre for homes, commerce, transport, industry and leisure. Peterborough is designated by the Government as part of the London-Stansted-Cambridge growth corridor. The opportunities and challenges of change and growth are, therefore, on the increase.

This book will help us to get Peterborough into perspective, giving residents a sense of identity and belonging. The facts, comments and illustrations within this publication will be of great interest to the native and to the newcomer, to the resident and to the tourist.

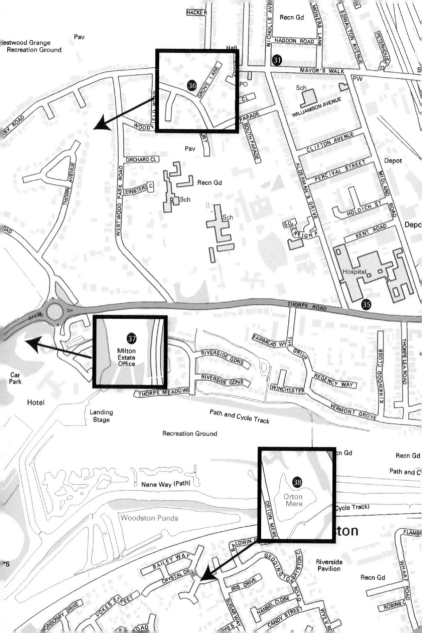

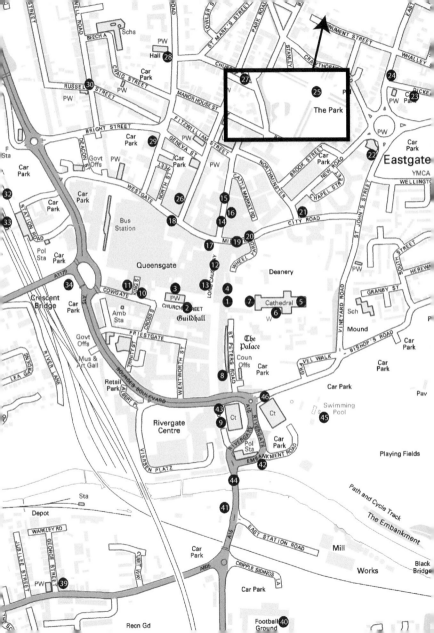

1. MARKET PLACE

The market place, originally named Marketstede, has been called Cathedral Square since 1963 when the covered market moved to Cattle Market Road. Here, in this 1903 view, we have every conceivable method of transport on show from the horse-drawn bus, tram, horse and cart, cyclist and pedestrian! It really was a bustling city! On the right, you can see the memorial to Henry Pearson Gates – the first mayor of the city. The monument was relocated in 1963 to Bishop's Gardens without its plinth, granite basin and taps. At the moment, Cathedral Square is being redeveloped, with fountains spouting up from the ground and new street furniture.

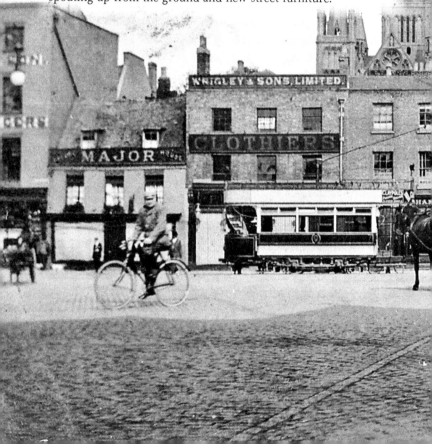

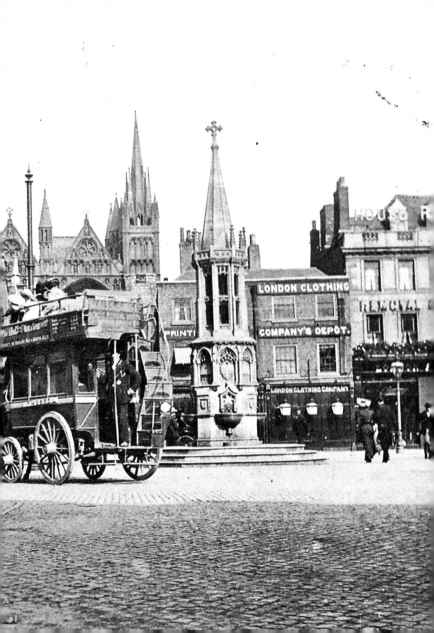

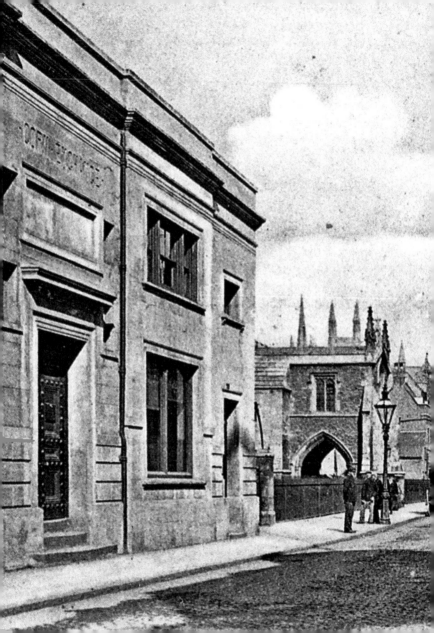

2. CHURCH STREET

A lovely 1905 view of Church Street looking towards Cathedral Square. The first Corn Exchange building is prominent in the foreground on the left. The site of the Corn Exchange is where the city's first theatre and playhouse stood, and the turning on the immediate right is Cross Street.

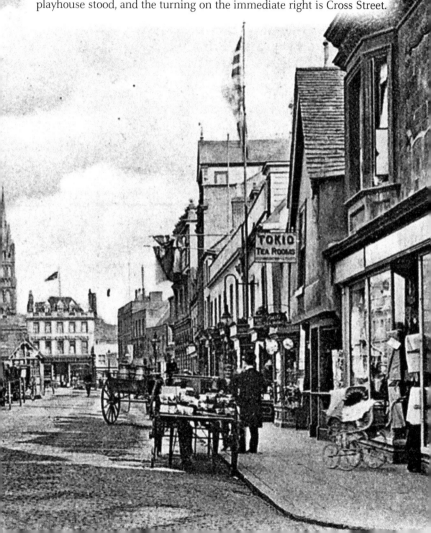

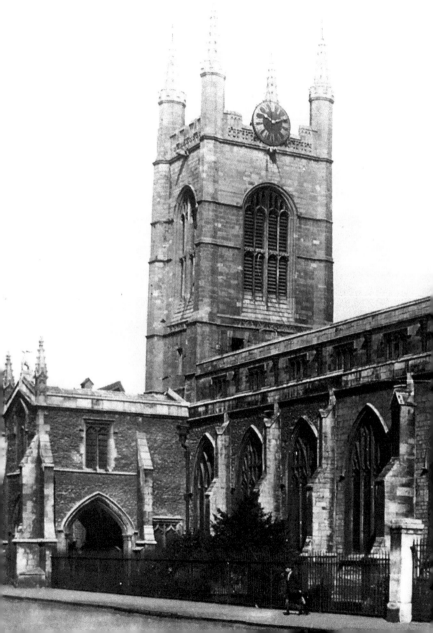

3. PETERBOROUGH BAPTIST CHURCH

St John the Baptist church is over 600 years old and was commissioned in 1402 and finished in 1407. It replaces an earlier church behind the cathedral, which kept being flooded. St John's was built as Peterborough's parish church – the cathedral was still a monastery at the time. This view is dated *c.* 1932. Today's view is little changed except the police post on the far right and public telephone box have gone.

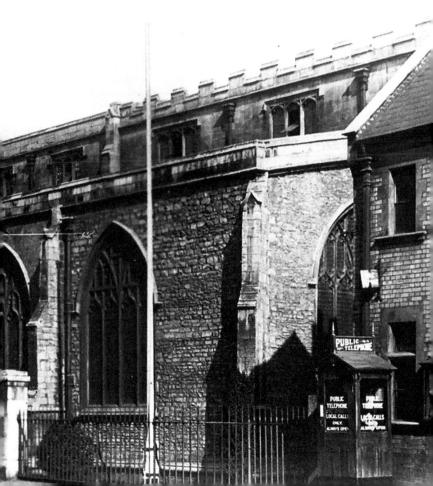

4. MARKET PLACE/CATHEDRAL SQUARE

This 1912 view shows Boots Cash Chemists with its lovely pargeted plasterwork, completed in 1911 when this branch was opened. In 1894, the first Boots was located in Narrow Bridge Street, with a second store opening a year later in Westgate. Today, the premises are trading as Pizza Express.

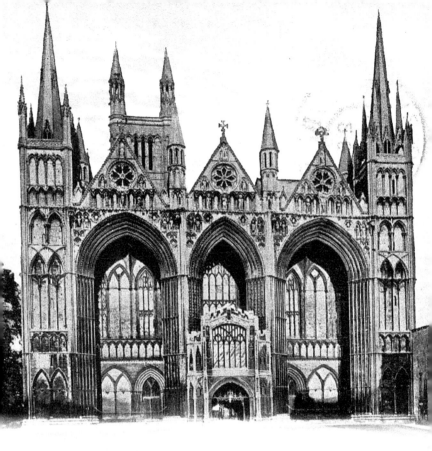

5. PETERBOROUGH CATHEDRAL

The Norman-style cathedral is built of Barnack stone and was begun in 1118 by Abbot Jean de Seez and consecrated *c.* 1238. During the Reformation, Henry VIII preserved the church and elevated its status to a cathedral in 1541. Catherine of Aragon, the first wife of Henry VIII, is buried here, as was Mary, Queen of Scots, until her body was exhumed and reinterred in Westminster Abbey in 1612. Monuments to their memory are features of the cathedral.

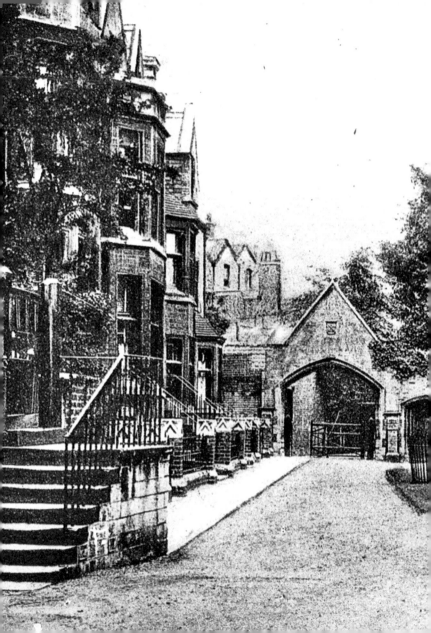

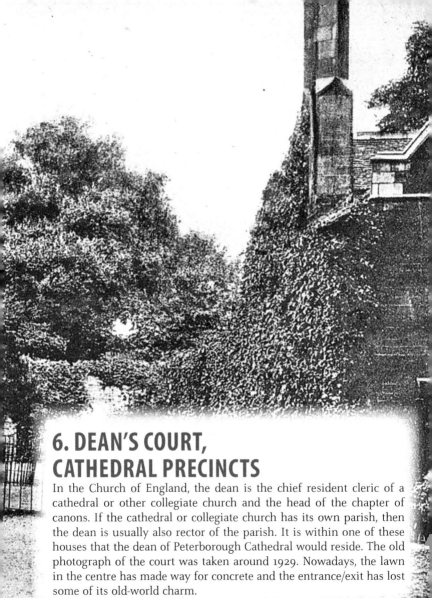

6. DEAN'S COURT, CATHEDRAL PRECINCTS

In the Church of England, the dean is the chief resident cleric of a cathedral or other collegiate church and the head of the chapter of canons. If the cathedral or collegiate church has its own parish, then the dean is usually also rector of the parish. It is within one of these houses that the dean of Peterborough Cathedral would reside. The old photograph of the court was taken around 1929. Nowadays, the lawn in the centre has made way for concrete and the entrance/exit has lost some of its old-world charm.

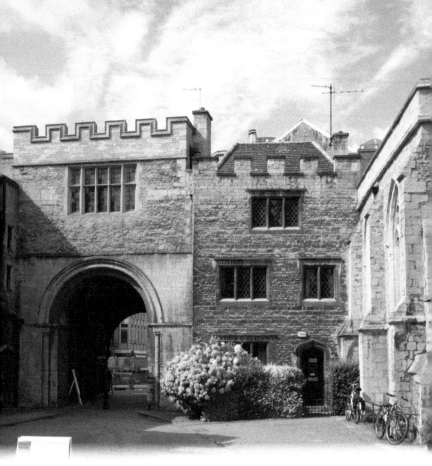

7. NORMAN GATEWAY TO CATHEDRAL

This is a 1901 view of the gateway leading to the cathedral. To the immediate right you can see a sign for the Cathedral Studio and then a sign for the museum. The Peterborough Natural History Society and Field Club formed in 1871 to promote interest in local natural history. Members included the surgeon at the hospital, Dr Walker, and local chemist, Mr Bodger. Within a decade, the society had expanded its

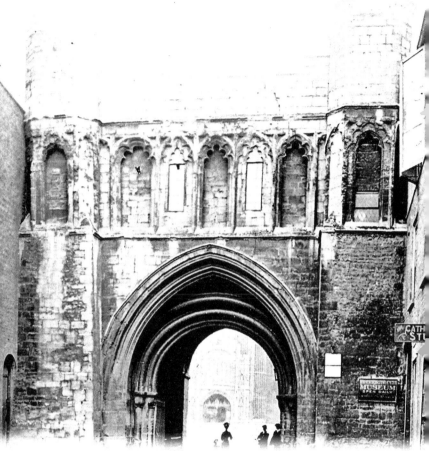

interests and laid the foundation of a museum and a library. It became the Natural History, Scientific and Archaeological Society, and in 1947, it was named the Museum Society. When the society began assembling the museum collections, the first collection was kept in a cardboard box under Mr Bodger's bed in Broadway. The collection was later moved to a former chapel in the Cathedral Precincts. The museum and its collections have been managed by Peterborough City Council since 1968, when the Museum Society gave them to the city.

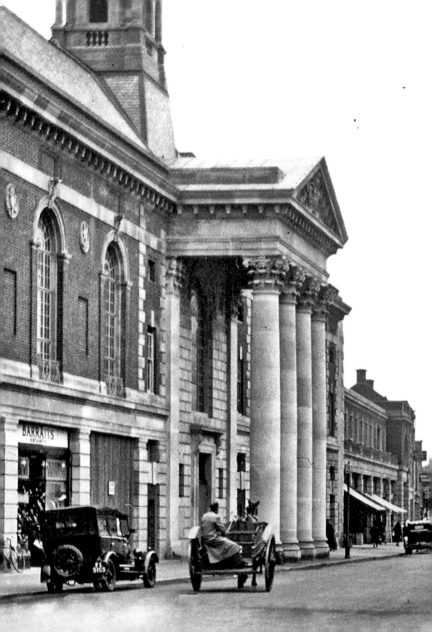

8. TOWN HALL, BRIDGE STREET

This view shows the new town hall, completed in 1933, with its Corinthian columns and wonderful portico. The building also housed the Welfare Centre and Clinic. On the right is the turning for Priestgate and the sign for the Angel Hotel is visible under the RAC sign. Note the volume of traffic while today the area is designated a pedestrian zone and various eateries provide al fresco dining on the tree-lined street.

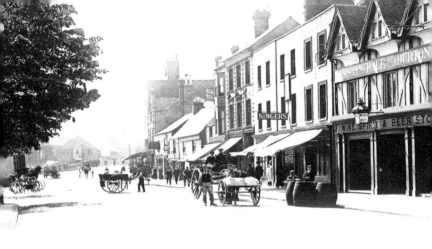

9. BROAD BRIDGE STREET

This 1906 scene shows Broad Bridge Street looking towards the river bridge. Bishops Road is the turning on the left and in the immediate right foreground is the family grocer W. Bodger, father of the museum curator Mr J. W. Bodger. Further forward from Bodger's is The Bull & Dolphin drinking saloon and wine store occupied by Alfred J. Paten from 1898 and at the time of this view. Nowadays, only one or two of the original buildings remain but otherwise properties have been demolished – principally to make way for the Magistrates' Court House on the left.

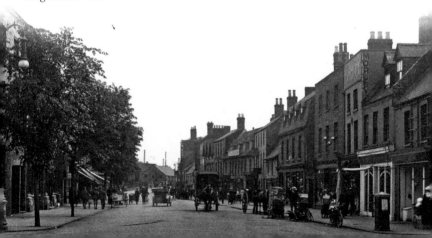

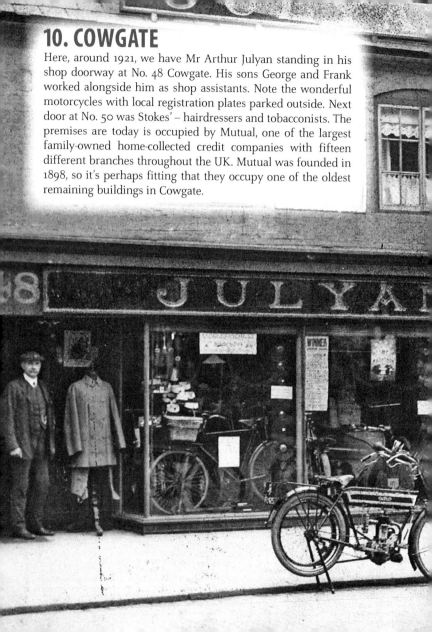

10. COWGATE

Here, around 1921, we have Mr Arthur Julyan standing in his shop doorway at No. 48 Cowgate. His sons George and Frank worked alongside him as shop assistants. Note the wonderful motorcycles with local registration plates parked outside. Next door at No. 50 was Stokes' – hairdressers and tobacconists. The premises are today is occupied by Mutual, one of the largest family-owned home-collected credit companies with fifteen different branches throughout the UK. Mutual was founded in 1898, so it's perhaps fitting that they occupy one of the oldest remaining buildings in Cowgate.

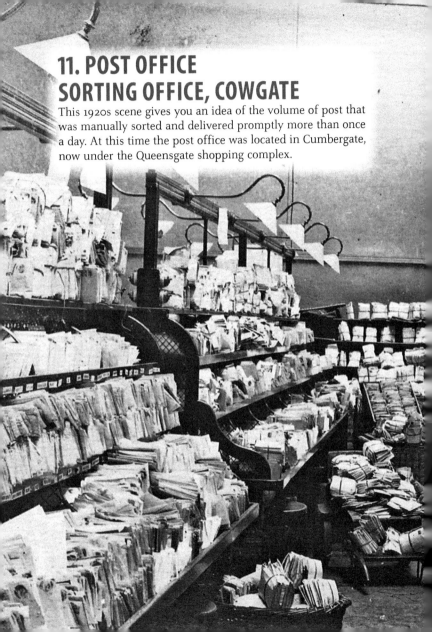

11. POST OFFICE SORTING OFFICE, COWGATE

This 1920s scene gives you an idea of the volume of post that was manually sorted and delivered promptly more than once a day. At this time the post office was located in Cumbergate, now under the Queensgate shopping complex.

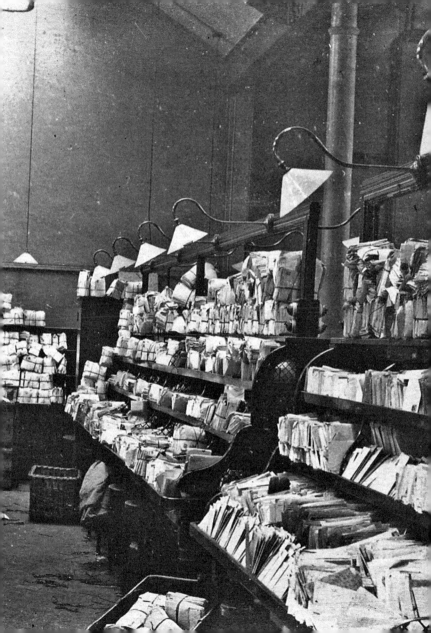

12. LONG CAUSEWAY

A splendid view from *c.* 1929 of a tram on its way to Newark from the market place, pictured here in Long Causeway. In the background is Barber & Ross, the grocer and provision store, with John W. Hall, the chemist, on the immediate left. Nowadays, there is a row of trees and seating, making the area look quite continental.

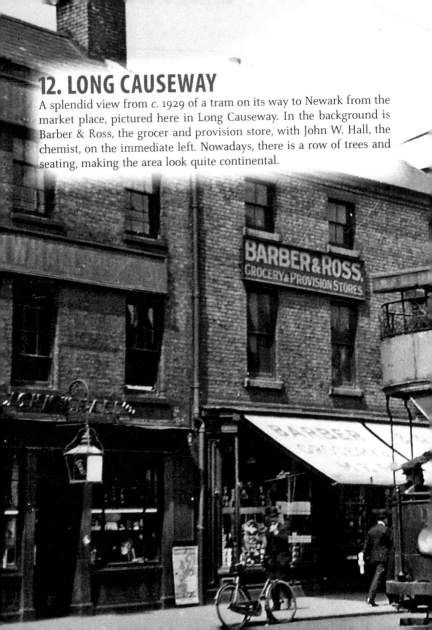

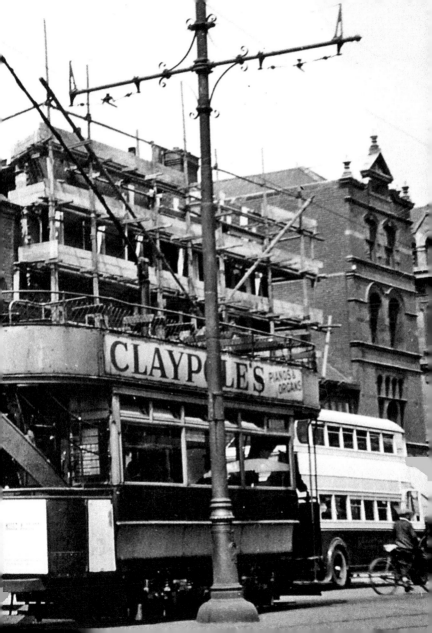

13. NO. 8 LONG CAUSEWAY

A 1919 view of the Salmon & Compasses pub – so named because the original Salmon & Compass pub had its windows smashed at the outbreak of the First World War. It seems a rumour started that Charles Guest made a derogatory remark about the King and became the victim of the mob's anger. The original pub was in the block between Market Place and Cumbergate and only had a small frontage as part was occupied by the gunsmith Charles Francis. The rebuilt pub, shown here, still had the landlord Charles Guest when the war ended. He remained as landlord until 1925. The building was demolished in 1931. Presently, the site is occupied by the Orange mobile phone store.

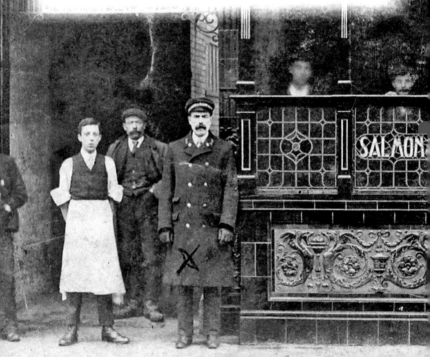

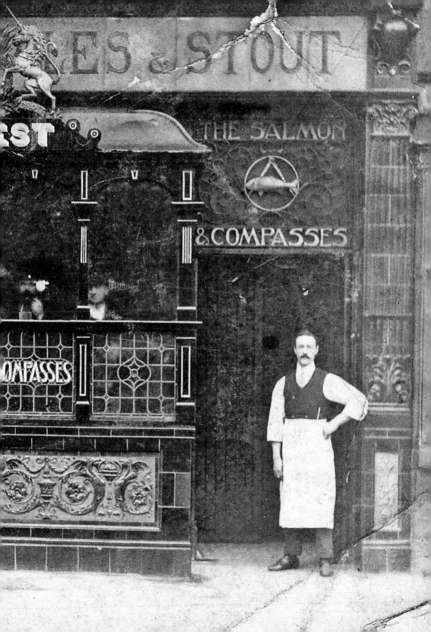

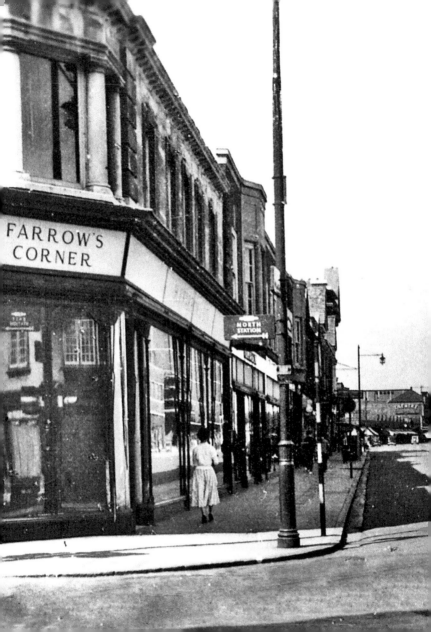

14. BROADWAY

A lovely 1950s view of Farrow's shop on the corner of Westgate and Broadway. Westgate would take you to the North station, as the signpost indicates. Centre-right is the Embassy Theatre building on Broadway where, in 1962, The Beatles appeared on their first tour. For one night only (a Sunday) they supported Adam Faith just before the first interval. Within two weeks, Beatlemania broke out. The scene today is very clinical compared to yesteryear.

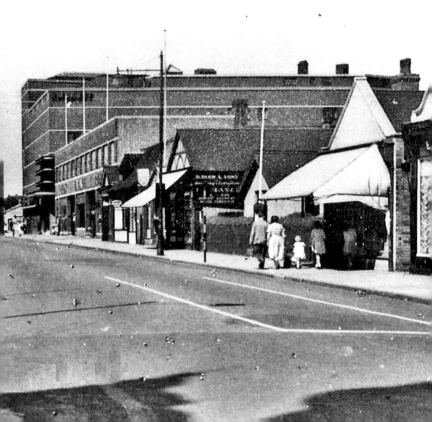

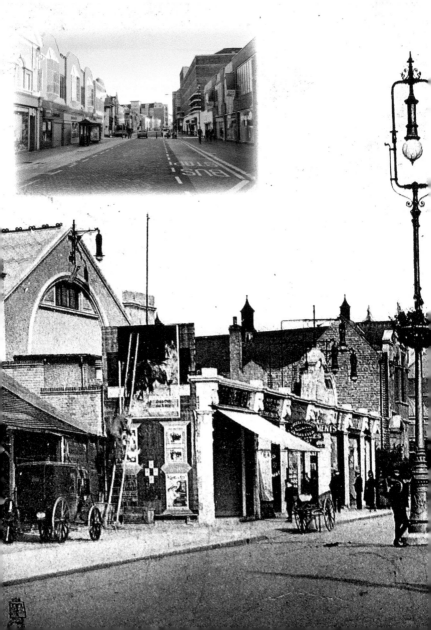

15. THEATRE AND ENTERTAINMENT AREA, BROADWAY

We can see the Hippodrome on the right and the Theatre Royal top centre in this 1913 view of Broadway. The inset is the Theatre Royal in 1912. In 1908, the Hippodrome was bought by the theatrical troupe owner Fred Karno. The likes of Charlie Chaplin and Stan Laurel worked for Karno. The Hippodrome became the Palladium in 1922 and then The Palace in 1924.

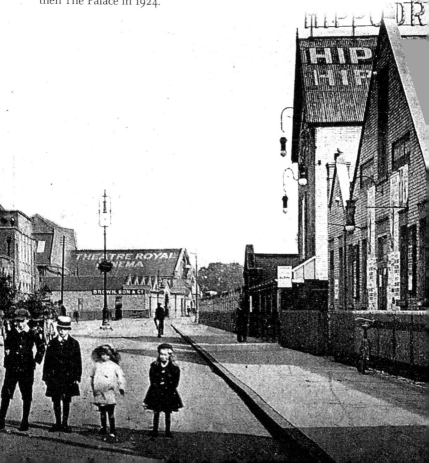

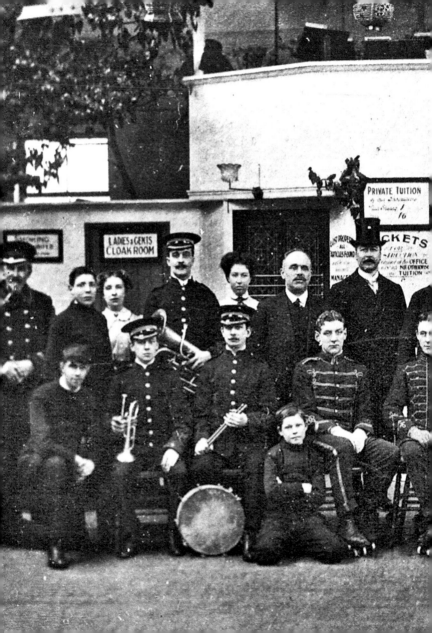

16. ROLLER-SKATING PAVILION RINK

What a great place to spend some leisure time. The pavilion rink, pictured in 1911, was situated on Broadway on a site now occupied by Tesco. The building was opened on 8 December 1909 and here we have an internal view with all the staff, including the owner and a brass band. An hour's tuition with the hire of skates would set you back 1s 6d. Often, the pavilion would have themed seasons and this one looks to be oriental from the hanging lanterns.

17. WESTGATE

An early 1950s scene. In the immediate left foreground is the civil defence headquarters. The gentleman is approaching No. 7 Westgate – occupied by Jack D'Arcy, the jeweller and watchmaker. Westgate Arcade is the white building left of centre. J. R. Johnson & Sons, the butcher's had the shop at No. 19 Westgate – at the entrance to Westgate Arcade. Now, there are many modern shop buildings and the advertising sign for the Bull Hotel has been replaced by graffiti. No one seems to live above the shops anymore and today there is a distinct lack of chimneys.

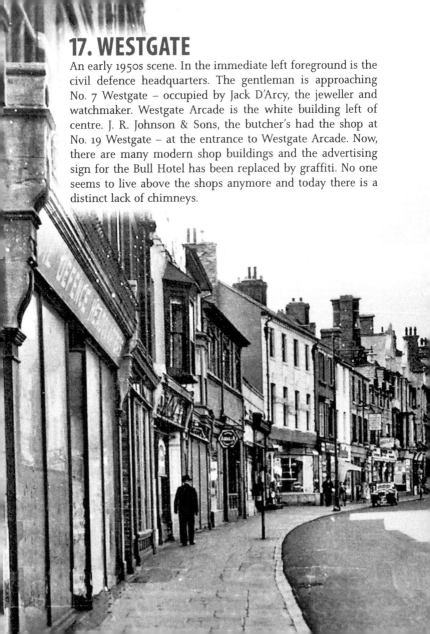

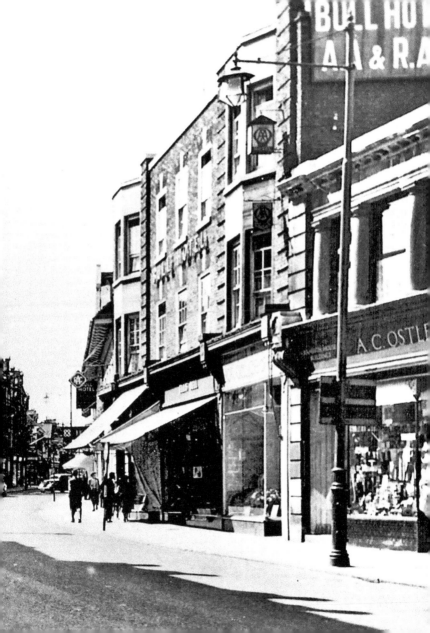

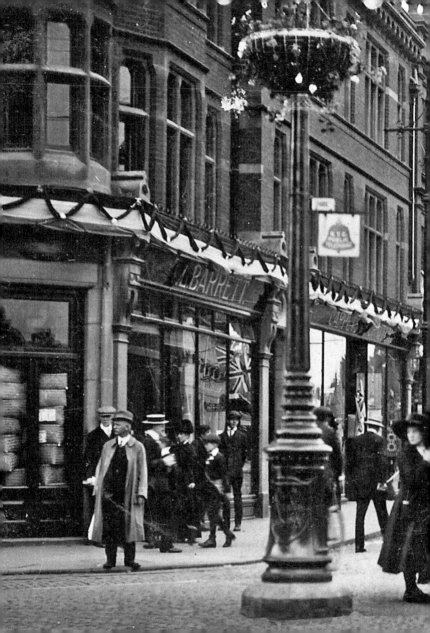

18. CORONATION OF KING GEORGE V, WESTGATE

What a splendid street scene with bunting and flowers and people on their way to celebrate the crowning of the Sovereign King George V and Queen Mary on 21 June 1911. The left foreground is where T. L. Barrett Ltd, the grocer's business stood. T. L. Barrett also had a shop on the opposite side of the road at the corner of Long Causeway and Midgate, known locally as Barrett's corner. This photograph is taken before Westgate Arcade was built; Craig's auctioneers and the adjacent building can be seen centre left. Nowadays, street signage obstructs the view.

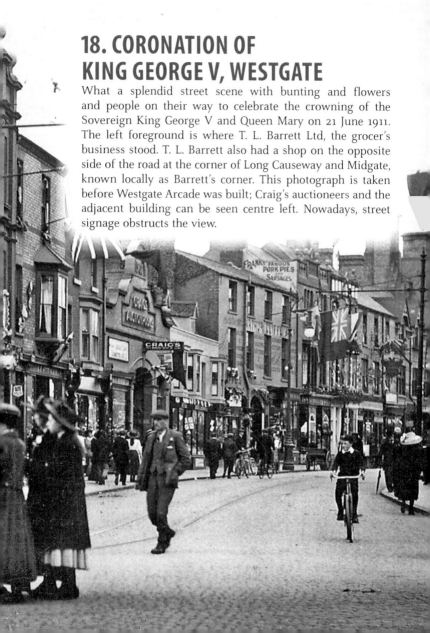

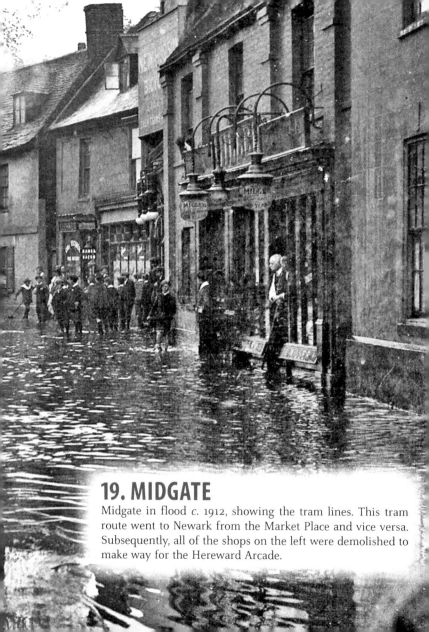

19. MIDGATE

Midgate in flood *c.* 1912, showing the tram lines. This tram route went to Newark from the Market Place and vice versa. Subsequently, all of the shops on the left were demolished to make way for the Hereward Arcade.

BLOUSES
SKIRTS &c

HOLDICH

M. HOLDICH
63
BLOUSE SPECIALIST

20. NOS 63–65, MIDGATE

M. Holdich's tailor's shop in *c.* 1908. This double-fronted window display shows blouses and shirts on the left with a variety of goods on the right, which could be made within twenty-four hours. Today, the view is of Ladbrokes' betting shop.

MADE ·
TO MEASURE

BLOUSE
MADE ON THE PREMISES ︱ THE NOTED BLOUSE SHOP ︱ MOURNING
IN 24 HO

M. HOLDICH
65.
DRAPER.

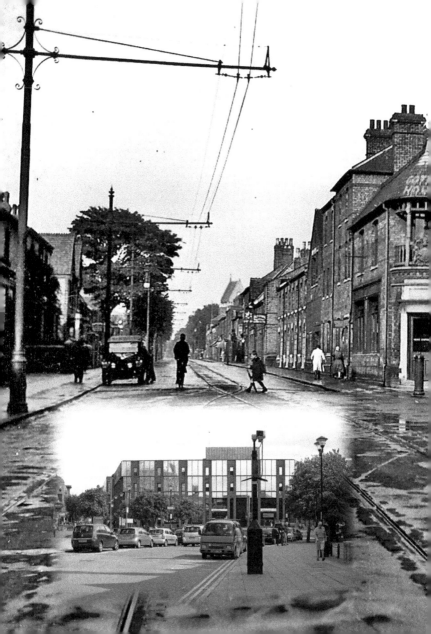

21. NEW ROAD/CITY ROAD

A view of the Fitzwilliam Coffee House (*c.* 1926), which stood at the corner of the junction with New Road and City Road and closed in the late 1920s. After the First World War, it was used by the Ex-Servicemen's Club. The coffee house was owned by the Peterborough Coffee House Co. Ltd, who also owned the Bedford Temperance Hotel at the corner of Exchange Street and Queen Street. Now, the view is barely recognisable with the government offices and CCTV in place.

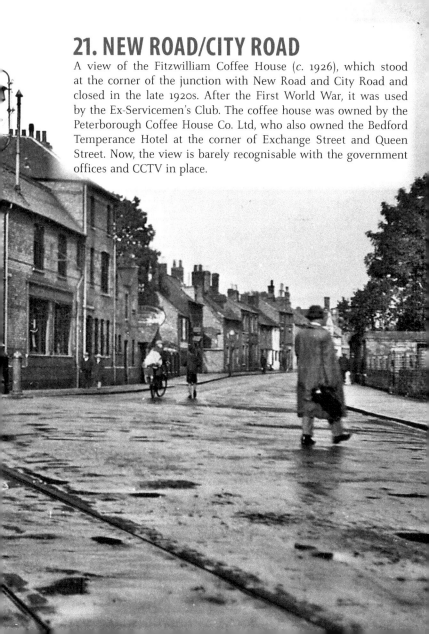

22. ST JOHN'S STREET, BOONGATE

This street connects New Road junction with Crawthorne Road to Vineyard Road. It was named St John's Street because the original Peterborough parish church of St John the Baptist was sited at the southern end, where the Bishop Creighton School stands today. This 1910 view shows St John's Street ahead with New Road off to the right. St Mary's church tower can be seen on the right. On the left, there are pillars marking the entrance to the Gas Works. These days, the view is unrecognisable. The old church has been demolished together with the heritage houses. The new St Mary's is a modern, well-equipped church with meeting rooms for hire.

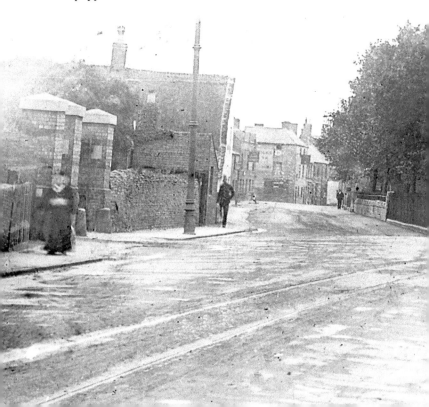

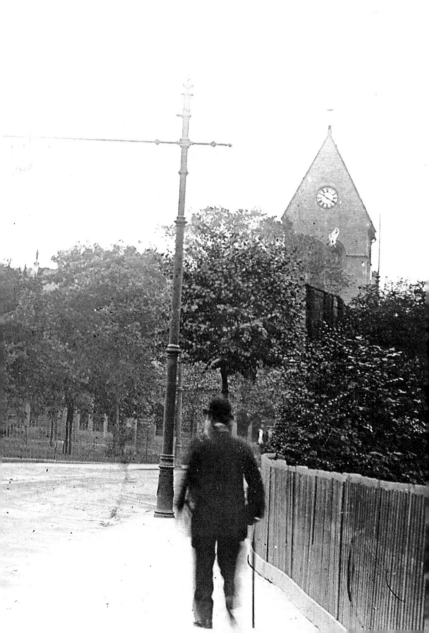

23. DICKENS STREET

At the time of this *c.* 1911 postcard of Dickens Street, the road linked Eastfield Road to Star Road. The street was named after John W. Dickens, who was from a local family business of monumental masons and land owners. In this real photographic postcard, you can see a horse and cart pulling a paraffin oil tank. Dickens Street is just a cul-de-sac off Eastfield Road and it seems to have lost some of its old-world charm.

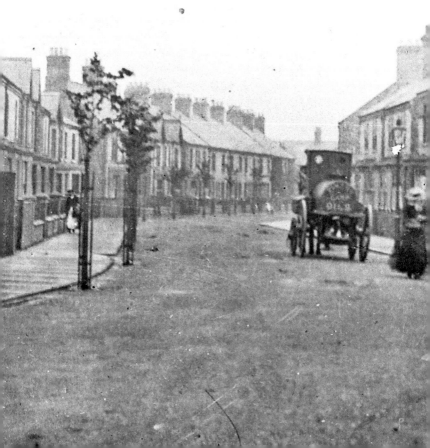

24. EASTFIELD ROAD

This *c.* 1915 postcard shows sheep being driven from the direction of Newark down Eastfield Road to the cattle market, situated off Broadway. Tramlines are visible in the road and only pedestrians and cyclists can be seen in the distance. Imagine the chaos if a flock of sheep were to be seen in the road today! In fact, sheep were sold in central Peterborough until 1863 when it was decided to form the Peterborough Cattle Market Company, which set about establishing the cattle market. Presently, the road is without much of its street furniture of lamp posts, tram wires and wrought-iron railings, and the cars, rather than the sheep, are the order of the day.

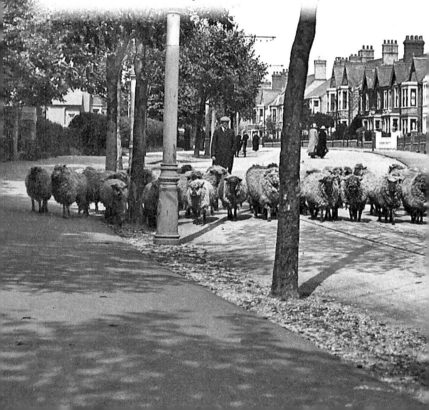

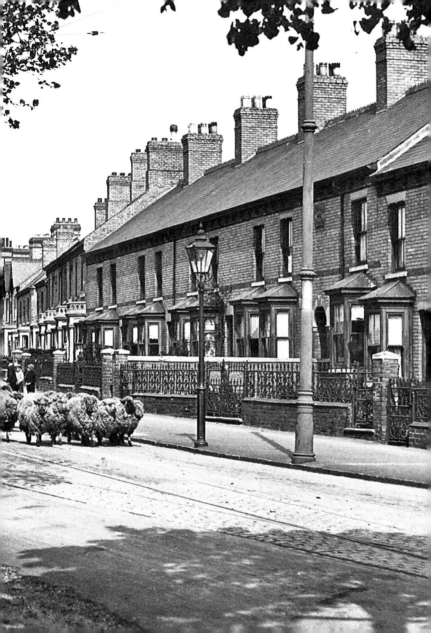

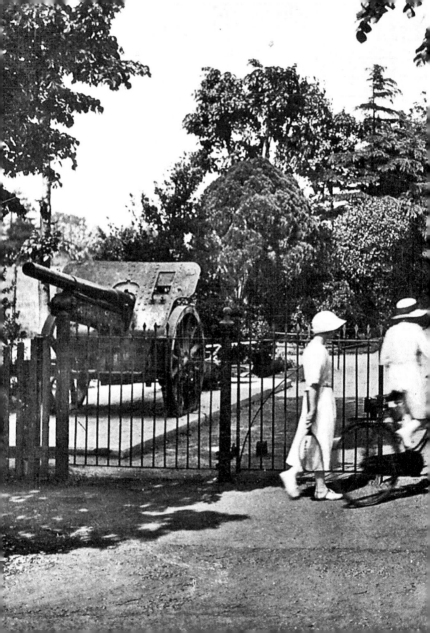

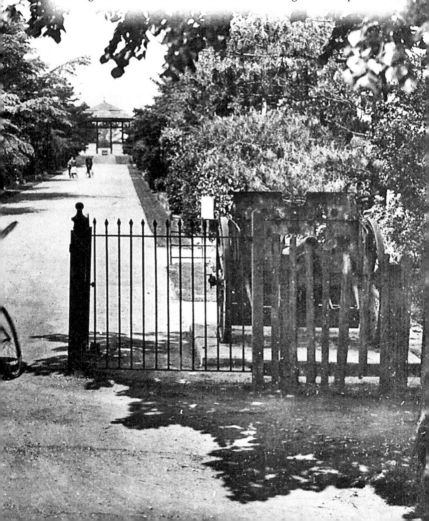

25. CITY PARK

Note the First World War field gun war trophies flanking the entrance of the city park around 1923. Nowadays, the entrance is without the field guns, which were removed due to rusting and disrepair.

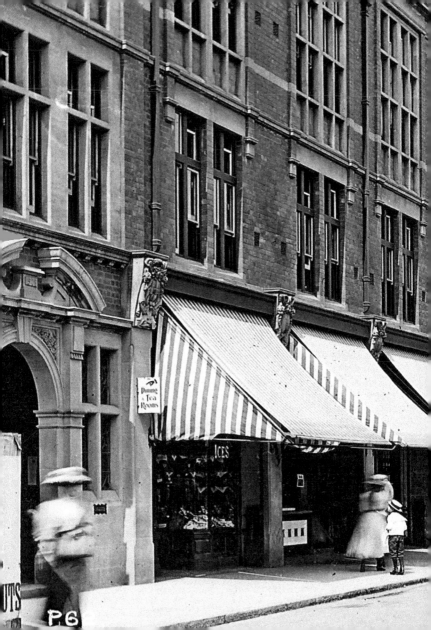

Dining & Tea Rooms

ICES

UTS

P6

26. PARK ROAD

This 1912 postcard depicts the Co-operative stores. The entrance to the dining and tea rooms is in the immediate left foreground and one of the store's horse and carts is parked outside. The growing importance of Peterborough attracted the society in 1876. The Dogsthorpe shop was opened in 1907 in a relatively quiet part of the city. Their main store here on the corner of Westgate and Park Road follows the modern concepts of the society, selling a restricted range of goods in designated parts of the shop. Thankfully, today, the Co-operative stores are still trading from the same premises as at the turn of the last century.

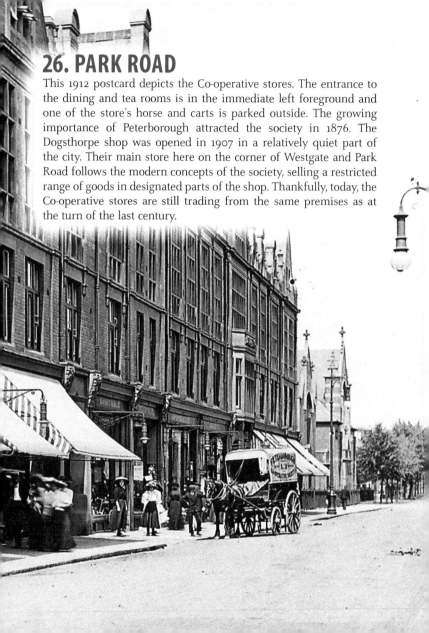

27. ALL SAINTS' CHURCH, PARK ROAD/ ALL SAINTS' ROAD

Here is a tranquil view of this Anglican church. In 1886, the foundation stone was laid, and a hundred years later the church undertook a successful fundraising campaign to provide a hall, a meeting room and an office. Today, overgrown trees completely mask the church and its tower.

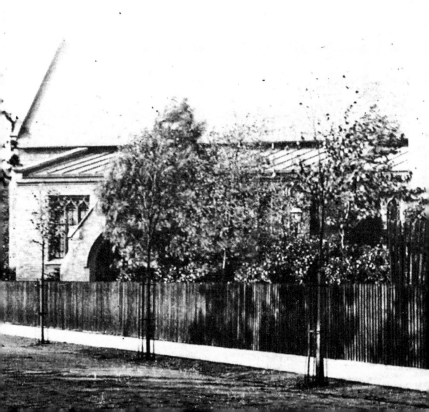

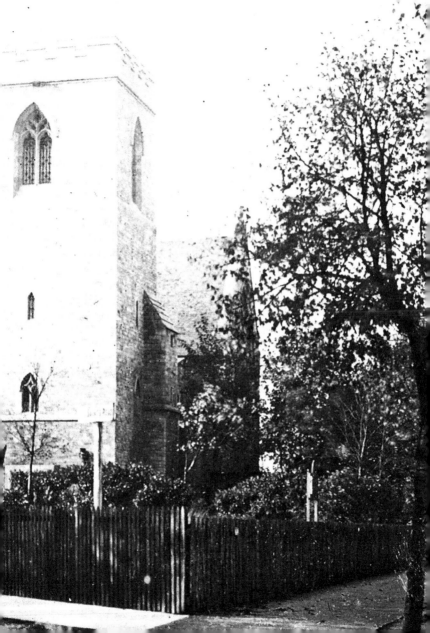

28. LINCOLN ROAD, NEW ENGLAND

The fountain on the right was built by John Thompson, a local builder and the first churchwarden of St Mark's church, Lincoln Road. It cost £300 and was presented to the parishioners of New England in 1884 by the Revd C. R. Ball and his sisters in memory of their parents, Rebecca and Joseph Ball. New England became a suburb in 1854, at which time the vast majority of the people living in the area worked for the Great Northern Railway Company. This photograph shows what the area looked like in 1912. Now, we are glad to say that the fountain remains a dominant feature next to the former public toilets building, with a resplendent clock tower that was also used as a bus stop and shelter.

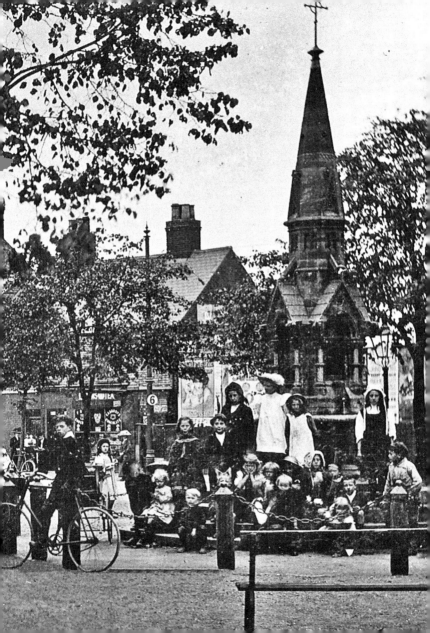

29. LINCOLN ROAD

This view *c.* 1904 shows the turning for Geneva Street in the right foreground. The first shop on the right is the fruit market shop at No. 41. On the opposite corner of Lincoln Road and Geneva Street is J. A. Alderman & Sons, tailors and outfitters. Adjacent to the lamp post on the right is the Rechabite Temperance Hall, located between Nos 47 and 49 Lincoln Road. The United Methodist Free Church can be seen further down on the left at the corner of Lincoln Road and Russell Street. The town end of Lincoln Road was called Boroughbury.

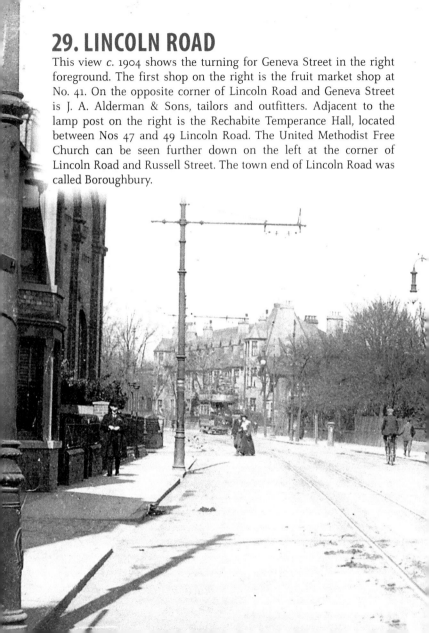

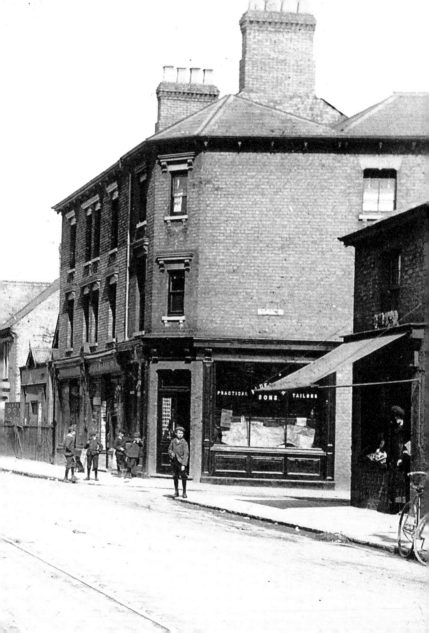

30. GLADSTONE STREET

This *c.* 1912 postcard shows Gladstone Street with Russell Street junction to the left and right, marked with crosses by the sender of this card. Gladstone Street is supposedly named after Prime Minister William Gladstone's elder brother Thomas, who put himself forward as an MP for Peterborough in the 1841 elections. Just look at the iron railings, tidy pavement and the empty road compared to the present-day assortment of varied shops and the sheer volume of parked cars.

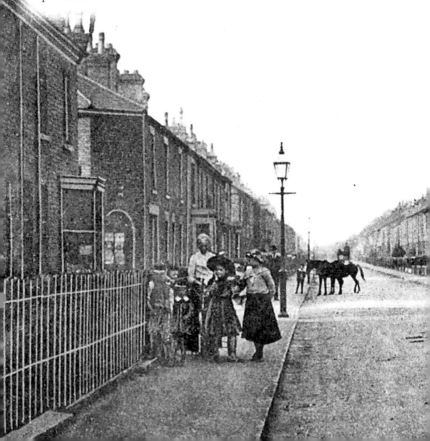

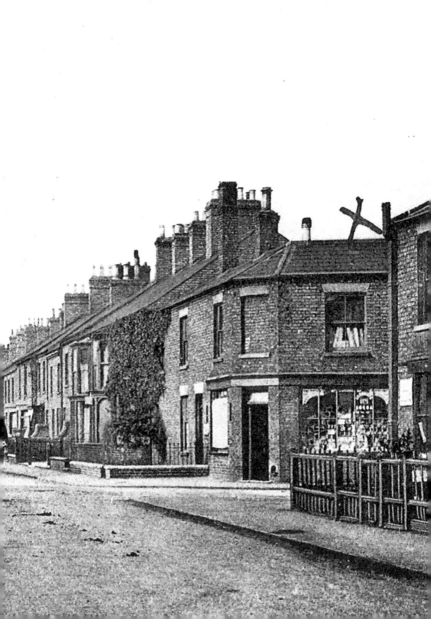

31. MAYOR'S WALK

This is a *c.* 1948 postcard view taken looking back towards Spital Bridge, with the turning into Alderman's Drive, second right, just after the sign to the Westwood Hotel pub. In the immediate right foreground is the post office, which is still there today, followed by the Co-operative store and butcher's shop, then the Westwood Hotel pub. Opposite the pub on the left is the turning to Nichols Avenue. The volume of traffic today and the number of parked cars provides a stark change. In fact, the scene at the turn of the last century looks quite tranquil.

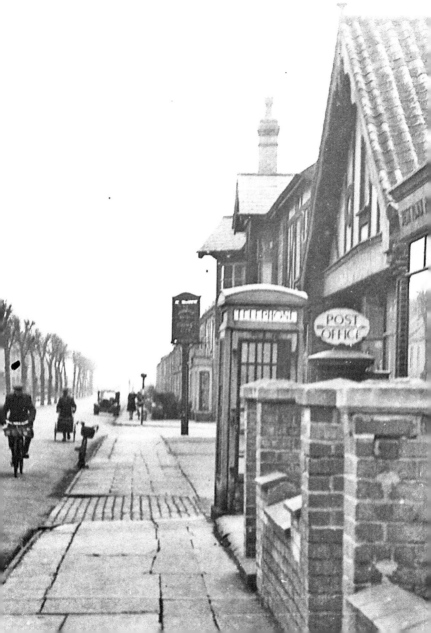

32. GN STATION

Note the Gresley Teak panelled coaches to the left in the south dock, and the parcel office portico entrance centre right. The main entrance to the station is on the extreme right of this *c.* 1922 postcard. The station opened in August 1850 and was the first direct route to London's Maiden Lane station and also the first important stopping place on the east coast route to the north. What a wonderful display of advertisement signs. Nowadays, there is nothing left to remind us of the elaborate Victorian station.

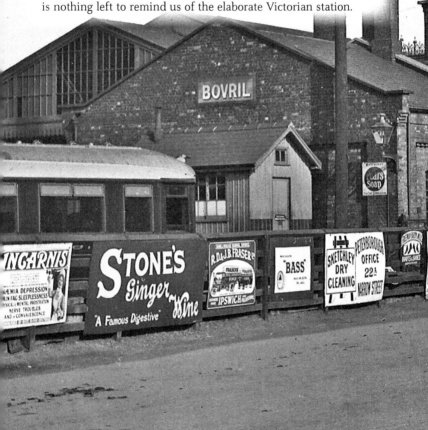

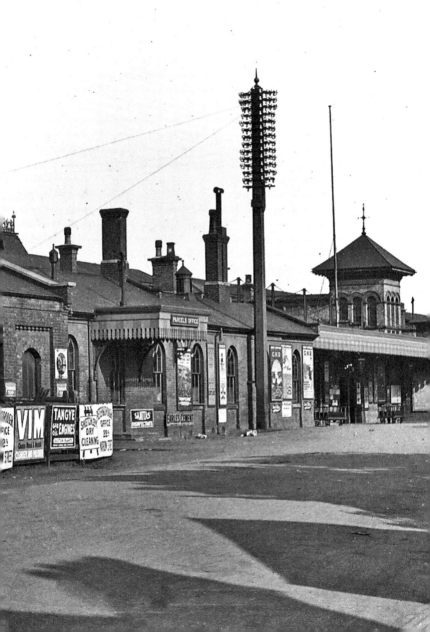

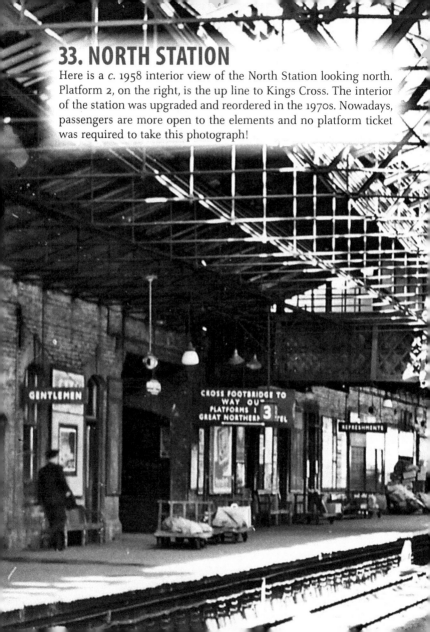

33. NORTH STATION

Here is a *c.* 1958 interior view of the North Station looking north. Platform 2, on the right, is the up line to Kings Cross. The interior of the station was upgraded and reordered in the 1970s. Nowadays, passengers are more open to the elements and no platform ticket was required to take this photograph!

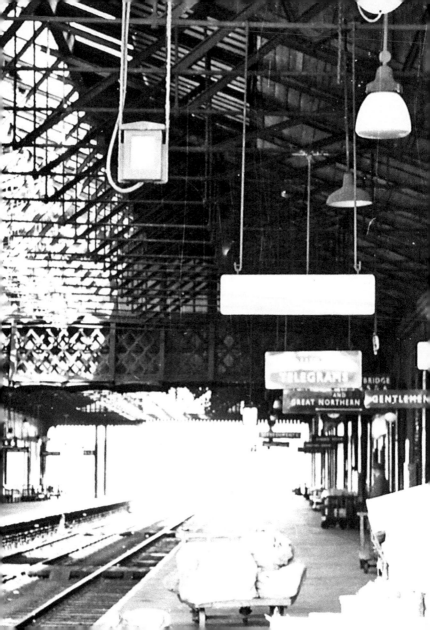

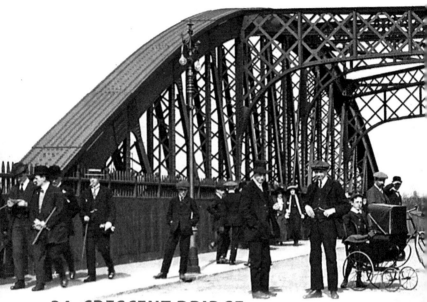

34. CRESCENT BRIDGE

In 1898, the Great Northern Railway Company decided to build a bridge to provide a safer crossing over the railway. The new Crescent Bridge, seen here in this 1913 postcard, was completed and officially opened on 16 April 1913 by the mayoress, Mrs J. G. Barford. The bridge was named after The Crescent, a row of Georgian houses demolished to make way for the new bridge. The director of GNR, who presided over the occasion, said during his speech that 'we have to make Peterborough a great railway centre'. These days, there are far fewer pedestrians and many more cars, and unless it's a Sunday, you can't see the road for stationary traffic!

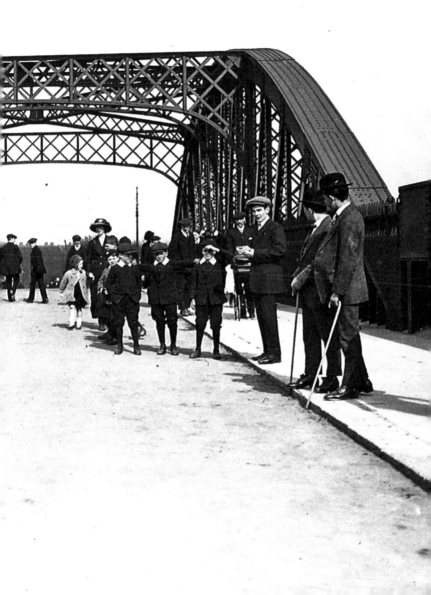

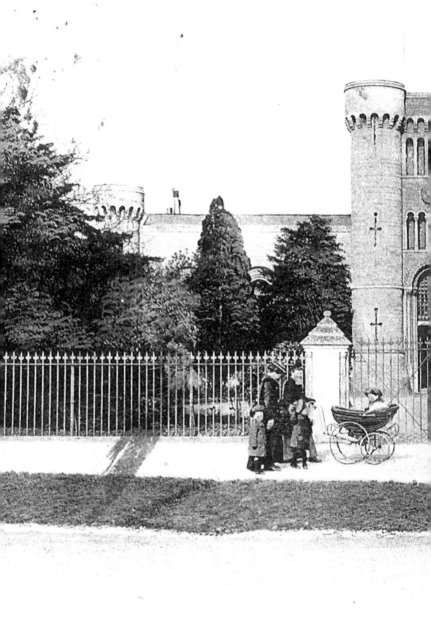

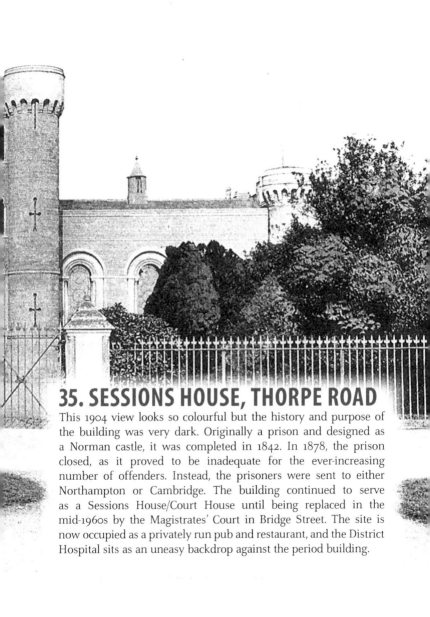

35. SESSIONS HOUSE, THORPE ROAD

This 1904 view looks so colourful but the history and purpose of the building was very dark. Originally a prison and designed as a Norman castle, it was completed in 1842. In 1878, the prison closed, as it proved to be inadequate for the ever-increasing number of offenders. Instead, the prisoners were sent to either Northampton or Cambridge. The building continued to serve as a Sessions House/Court House until being replaced in the mid-1960s by the Magistrates' Court in Bridge Street. The site is now occupied as a privately run pub and restaurant, and the District Hospital sits as an uneasy backdrop against the period building.

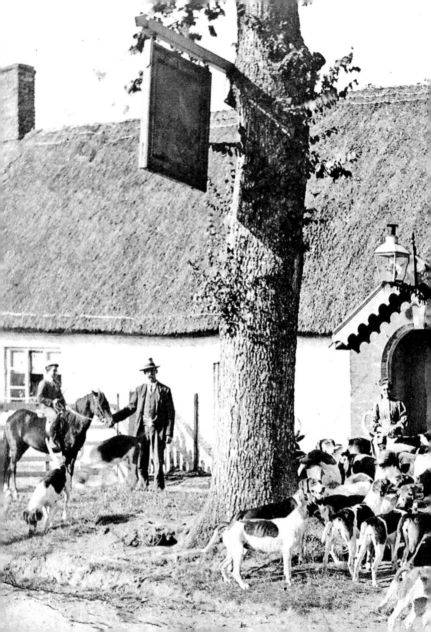

36. FOX & HOUNDS PUB, LONGTHORPE

Here we see the Fitzwilliam hounds outside the 1907 Fox & Hounds pub. These packs of hounds were descendents of the pack that was chief prize-winner at Redcar in September 1859. The Peterborough Foxhound Show was the first to be open to all England, although small-scale hound shows date back to the 1760s. The pub at this time was owned by Cooke Spirits & Wine Co. It is a completely different building today with dining rooms and a free house.

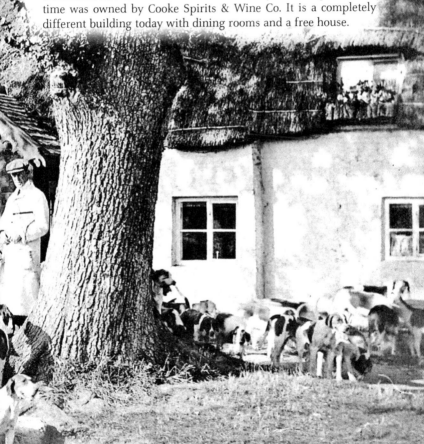

37. MILTON HALL

This view is dated *c.* 1912. Milton Estate consists of 23,300 acres extending along the Nene Valley roughly between Peterborough and Irthlingborough. The founder was Sir William Fitzwilliam, a merchant taylor, a merchant of the staple of calais and an alderman of the City of London; he was knighted in 1515. The oldest part of Milton Hall is part of the north front – built between *c.* 1590–1610. Milton Estates descended through the then Countess's family from her first marriage, initially to her daughter, Lady Elizabeth Anne Hastings, and then to her grandson, Sir Philip Naylor-Leyland. Sir Philip succeeded his father as baronet in 1987. He married Lady Isabella Lambton in 1980 and they have three sons and a daughter. Daphne du Maurier reportedly wrote her novel *Rebecca* while a guest at Milton Hall.

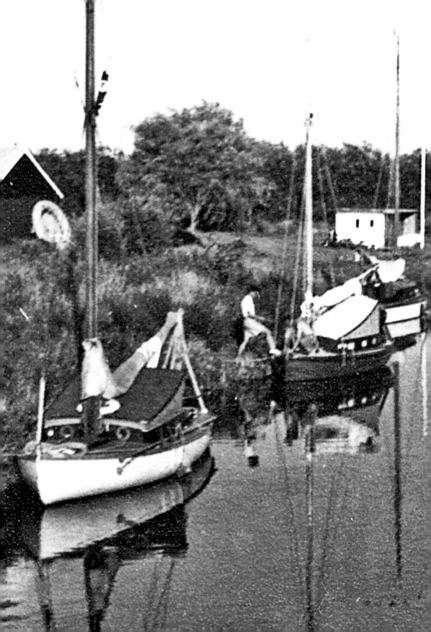

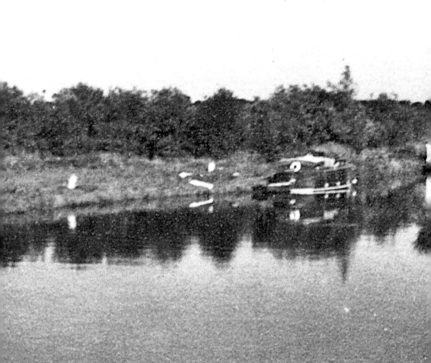

38. PLEASURE BOATS ON THE RIVER NENE, ORTON MERE

A late 1940s/early 1950s view of boating life on the River Nene, near Orton staunch. Today, pleasure craft are more popular. The River Nene flows for 91 miles through Northamptonshire, Cambridgeshire, Norfolk and Lincolnshire.

39. OUNDLE ROAD, WOODSTON

Here, in this *c.* 1919 postcard of Oundle Road, is the turning for George Street in the left foreground. Note the old Co-operative store centre right with the New Inn pub next door. H. S. Hunting's butcher shop at Nos 71 and 73 Oundle Road is on the immediate left, with the hand-drawn cart outside. Mr Piggott's shop is in the right foreground, followed by Mrs Younghusband's grocers and tea shop. Today, the New Inn pub is the Office pub and the shops have changed usage many times over. However, if you look above the shopfronts, the buildings are very much the same.

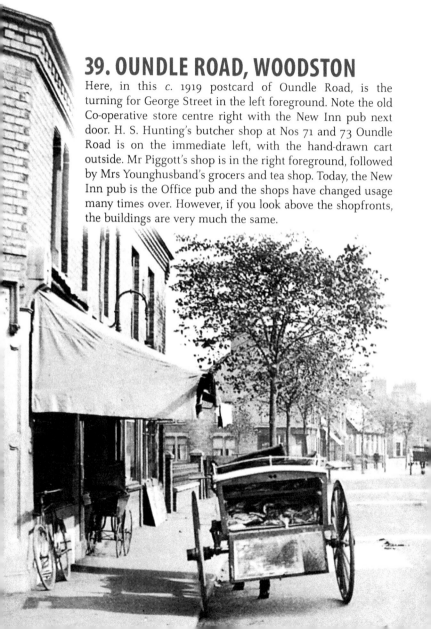

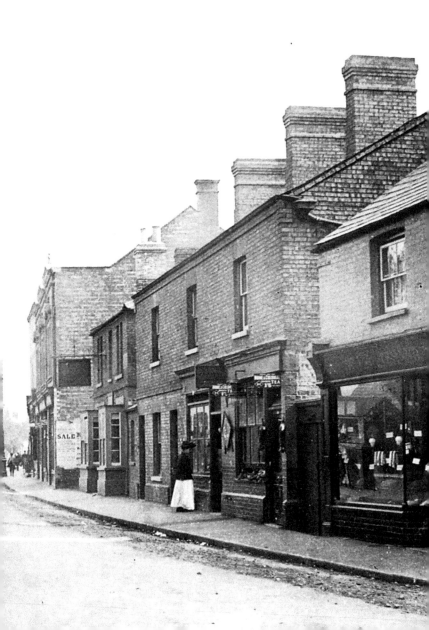

PETERBOROUGH CITY

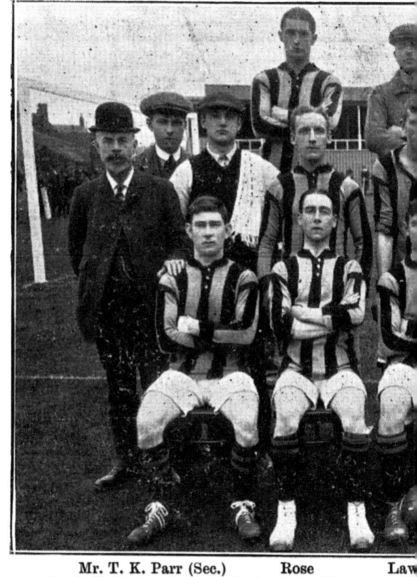

Mr. T. K. Parr (Sec.) Rose Law
Mr. J. H. Beech Barnes (Trainer) Gilbert W
Daviz Savern S. C

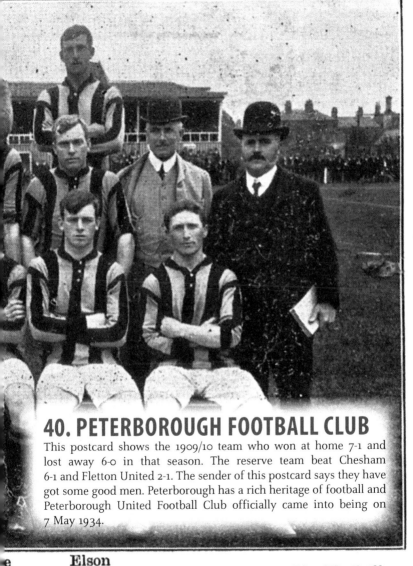

40. PETERBOROUGH FOOTBALL CLUB

This postcard shows the 1909/10 team who won at home 7-1 and lost away 6-0 in that season. The reserve team beat Chesham 6-1 and Fletton United 2-1. The sender of this postcard says they have got some good men. Peterborough has a rich heritage of football and Peterborough United Football Club officially came into being on 7 May 1934.

e Elson
 Tirrell Councillor Williamson Mr. W. Catling
orge Chambers Hartwell

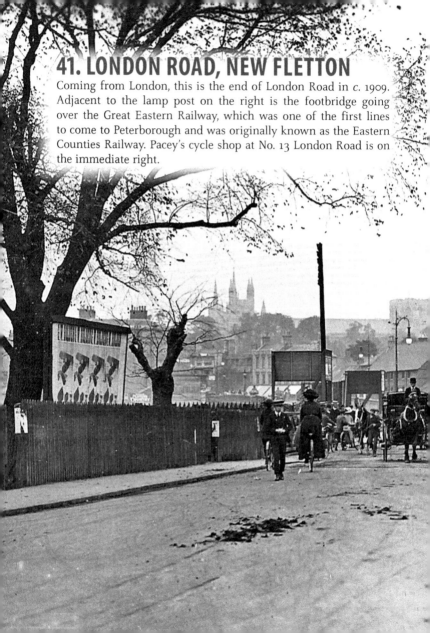

41. LONDON ROAD, NEW FLETTON

Coming from London, this is the end of London Road in *c.* 1909. Adjacent to the lamp post on the right is the footbridge going over the Great Eastern Railway, which was one of the first lines to come to Peterborough and was originally known as the Eastern Counties Railway. Pacey's cycle shop at No. 13 London Road is on the immediate right.

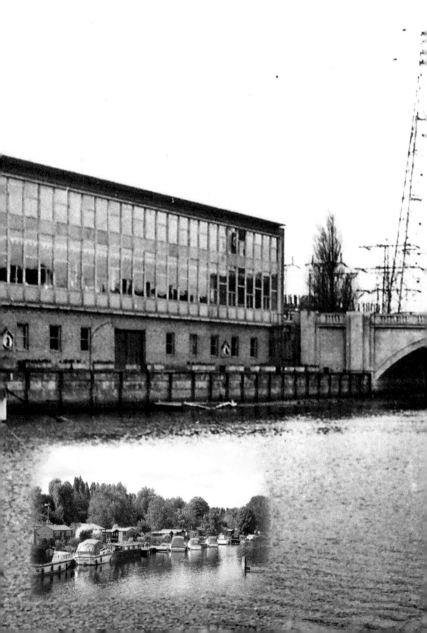

42. EMBANKMENT

Here is an early 1960s view of Bridge House on the left with buses and lorries on the bridge. Presently, the City Council is thinking of introducing water taxis to ferry people up and down the river. How eco-friendly is that!

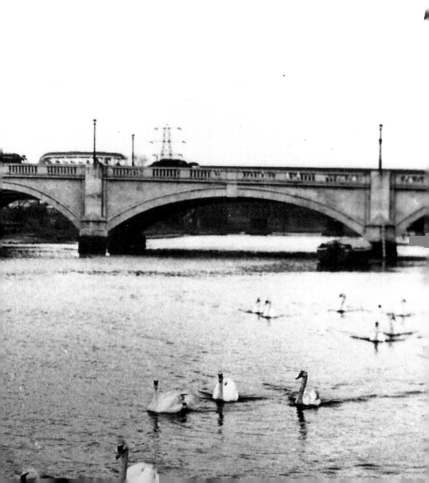

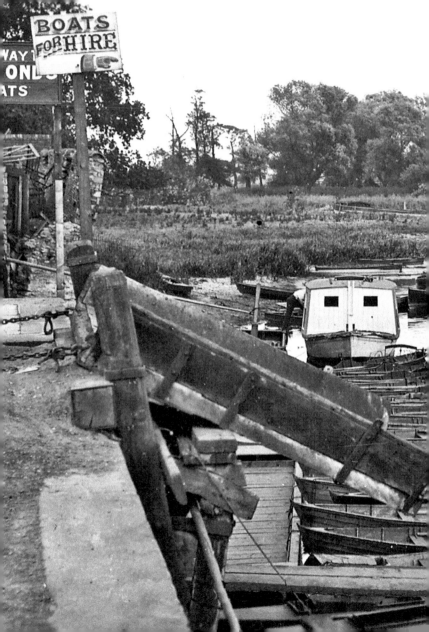

43. RIVER NENE AND HAMMOND'S BOAT HIRE

John Hammond's Boat Hire, Bridge Street, was the place to go for punting or canoeing on the river. This was a well-supported activity until the late 1960s. In this postcard of *c.* 1921, part of the Customs House can be seen on the left, adjacent to the white house boat. Presently, concrete has taken the place of the grass embankment and river boats are no longer available for hire.

44. BRIDGE FAIR, TOWN BRIDGE

The Bridge Fair is more than just a fair to Peterborough, it's an institution. Each October, the travelling fair rolls into Peterborough and the mayor opens it with the traditional proclamation, followed by a sausage and mash supper. This 1904 picture is taken just before the London Road level crossing. The mayor's procession is centre left. This photograph is taken from the top of the old footbridge. Today, the view is completely unrecognisable.

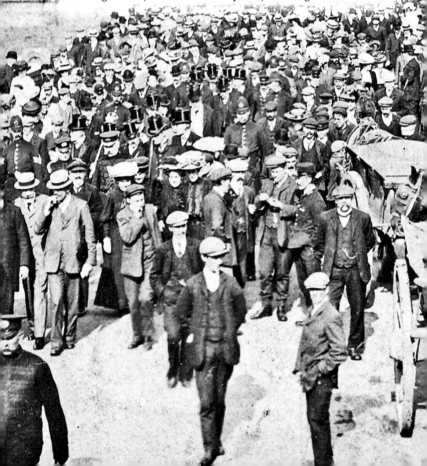

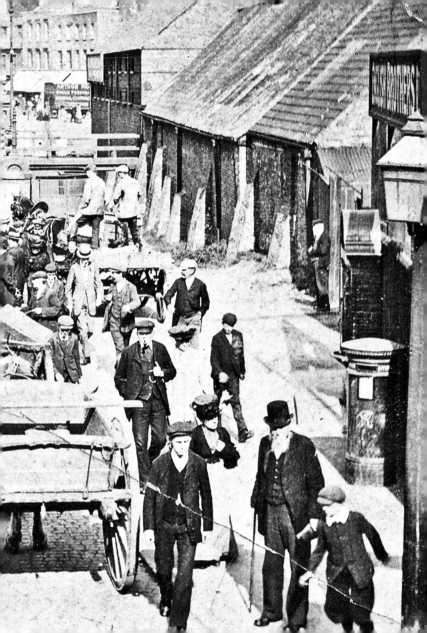

45. PETERBOROUGH LIDO

Situated in Bishops Road, the open-air swimming pool was built in 1936 to the design of a local panel of architects. Shown is a late 1940s/early 1950s view of the Lido. There are two pools, the larger being 165 feet by 60 feet with a three-tier diving platform. The smaller children's pool is 70 feet by 24 feet and can be seen on the far right of this picture.

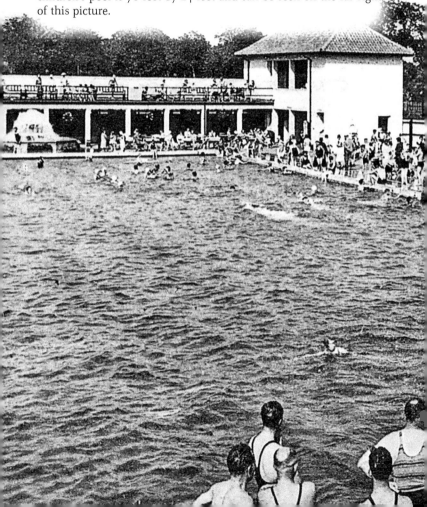

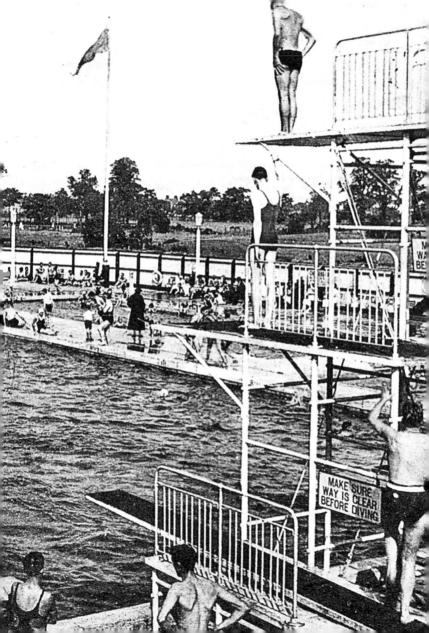

MAKE SURE
WAY IS CLEAR
BEFORE DIVING

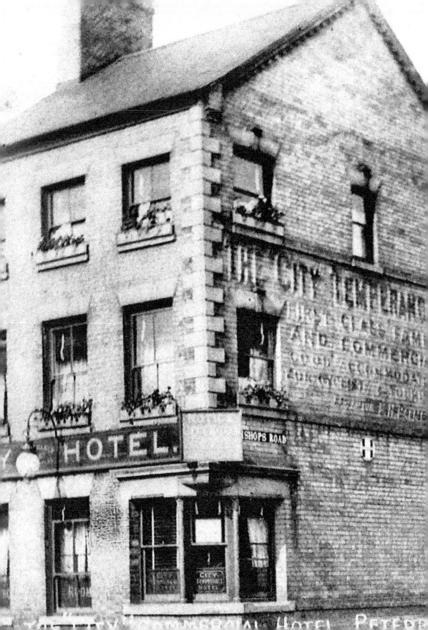

THE CITY TEMPERANCE HOTEL
...AND COMMERCIAL
GOOD ACCOMMODATION
FOR CYCLISTS & TOURISTS

HOTEL

BISHOPS ROAD

46. CITY COMMERCIAL HOTEL

Situated on the corner of Bridge Street and Bishops Road, the hotel was originally a private house. This 1911 postcard advertises the hotel as the City Commercial, while the advertisement on the Bishops Road side of the hotel shows it as The City Temperance. In November 1936, the hotel was severely damaged after a gas explosion, which injured nine people and damaged much of the hotel. Poundland currently occupies the site.

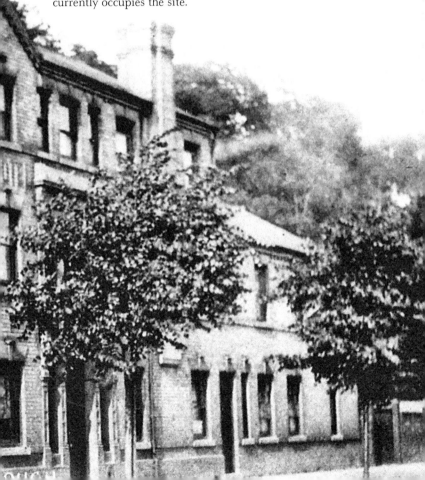

ACKNOWLEDGEMENTS

In compiling the content for this book, we sought to ensure that the text content is factually correct to the best of our knowledge, compelling and inspirational. We felt it had to be written with authority, locally, in the correct context for both the geographical area and the subjects about which we write. The authors are indebted to the following people, without whose help this book would not have been possible: Messrs Harry Miles and John Jack Gaunt, John and Josephine Gillatt, Stanley Hoare, Harry and Gwen Hurst, John and Vera Seeley, Susan Ross and Alan Sutton for marketing. Additionally, we owe our very grateful thanks to Ian Wilson for some of the modern-day city centre photographs.